THERE
BUT
NOT

D1494222

THERE BUT NOT

JOSE
DÁVILA

powerHouse Books
BROOKLYN, NY

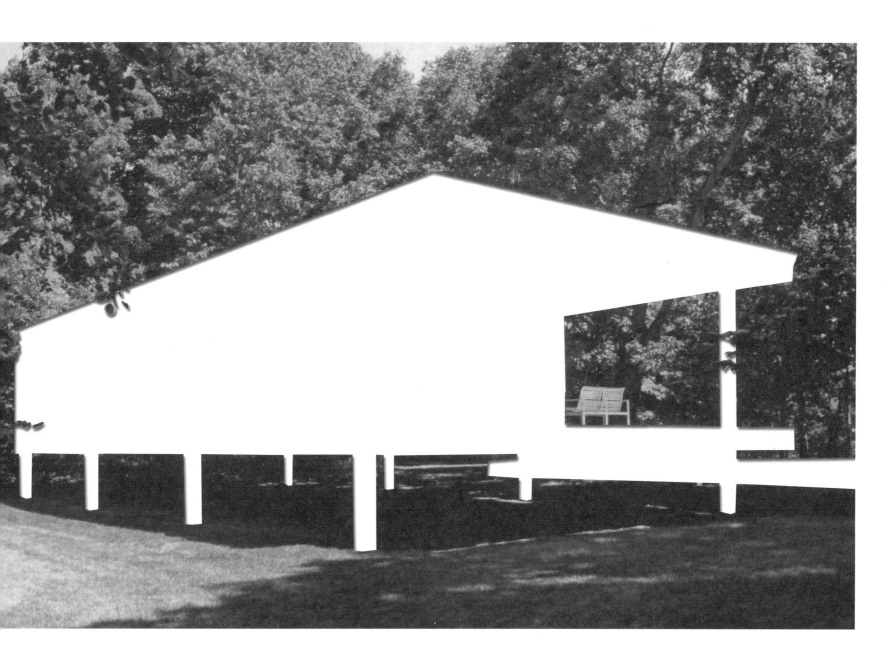

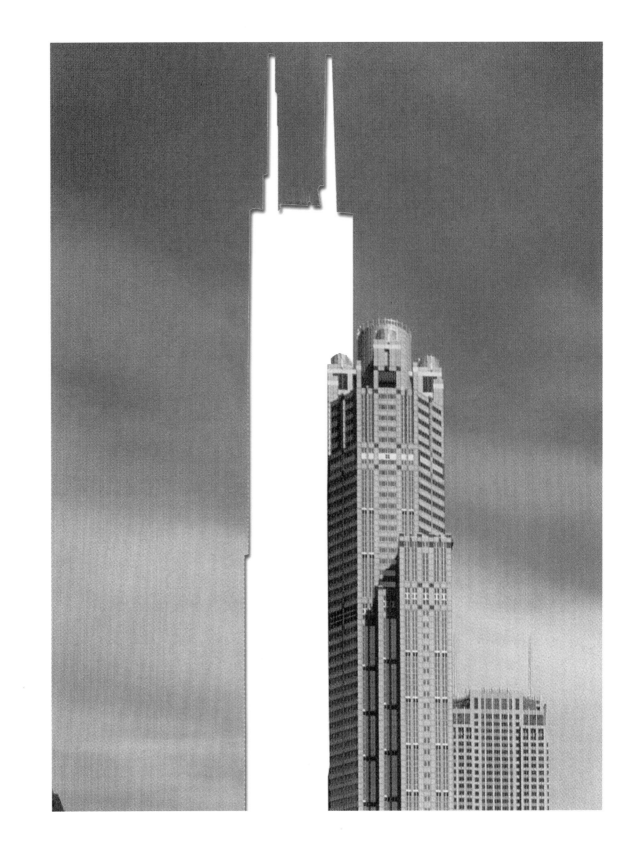

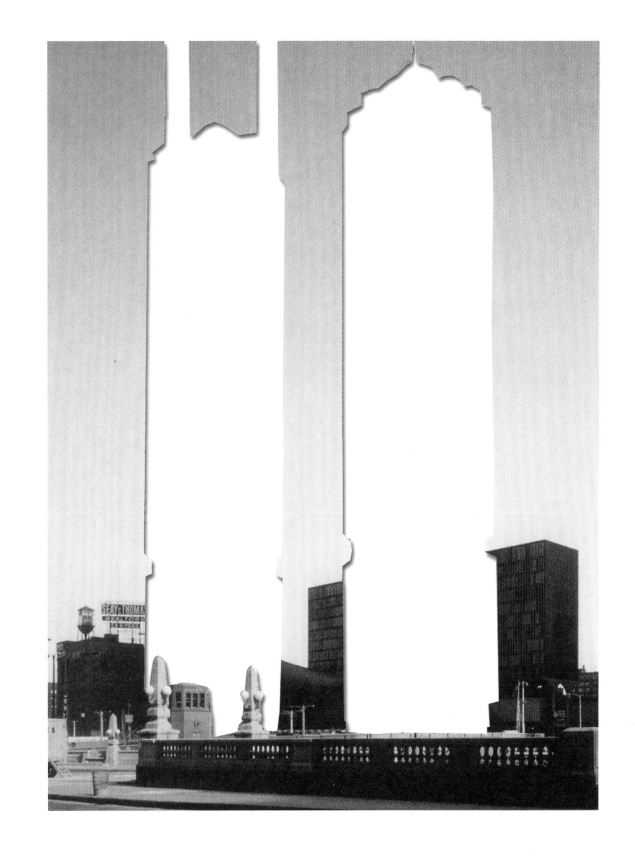

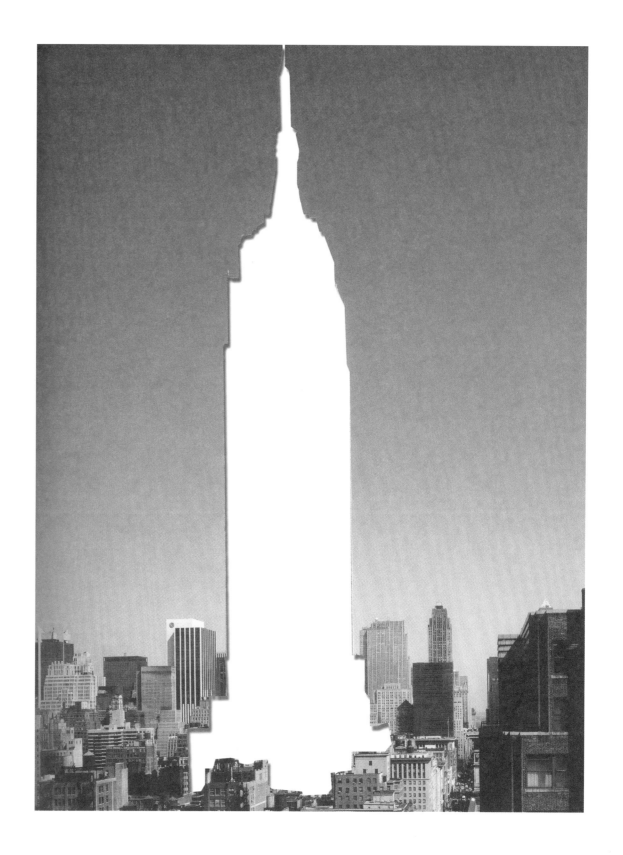

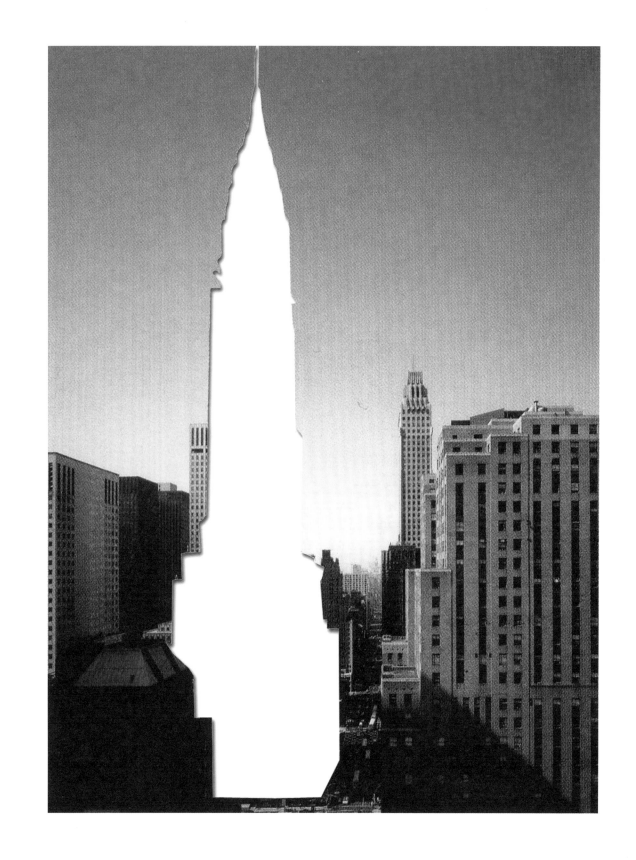

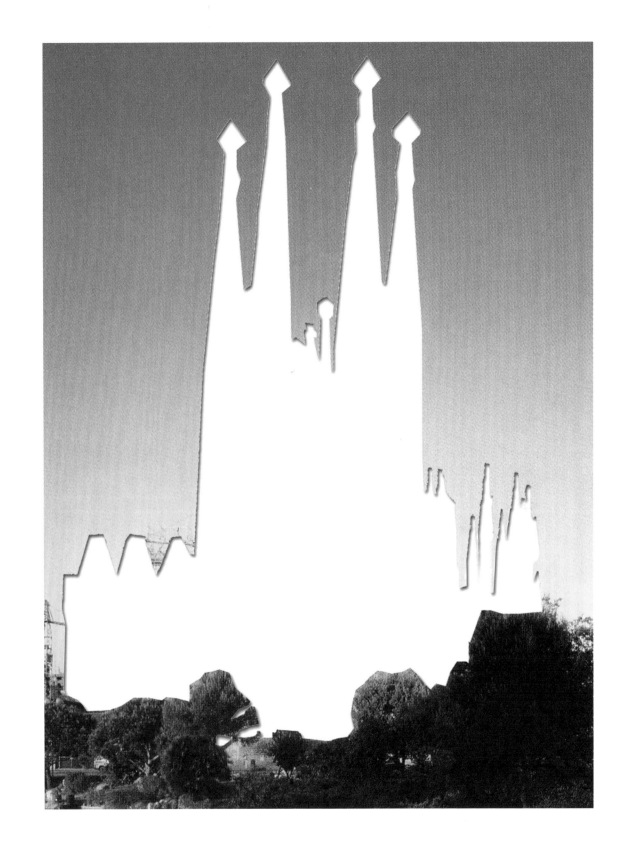

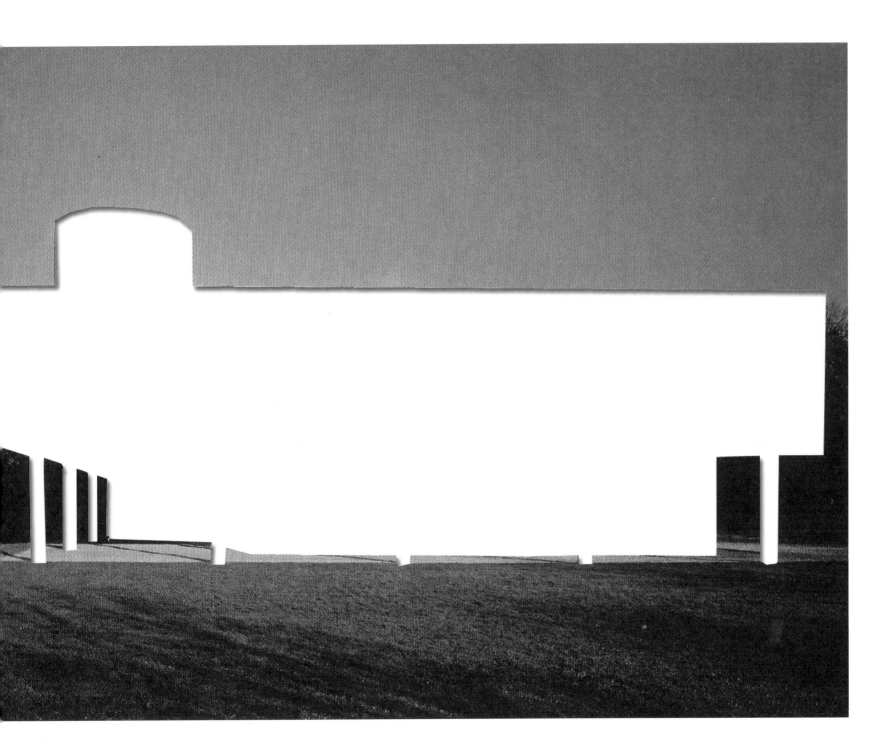

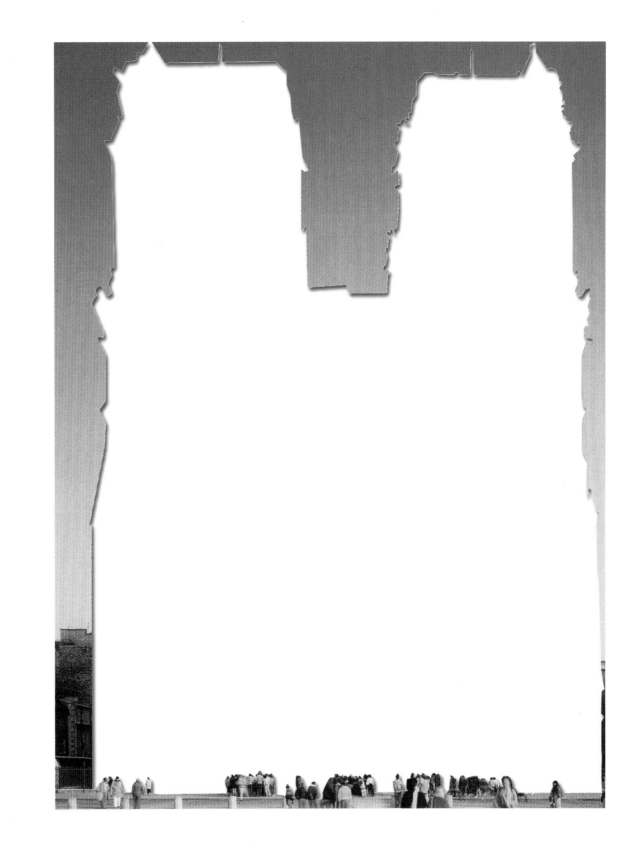

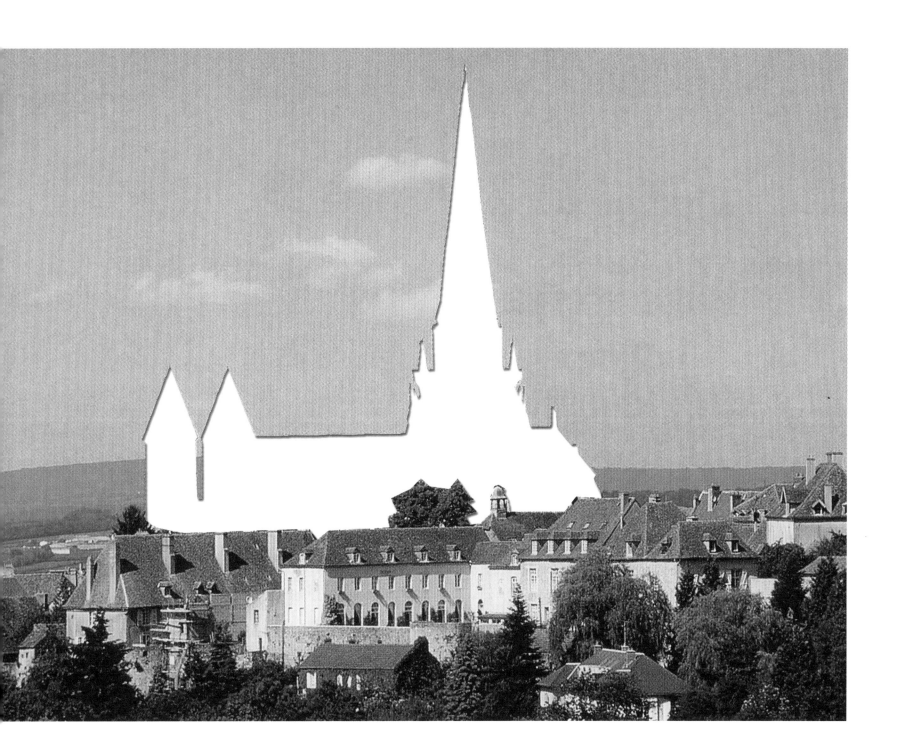

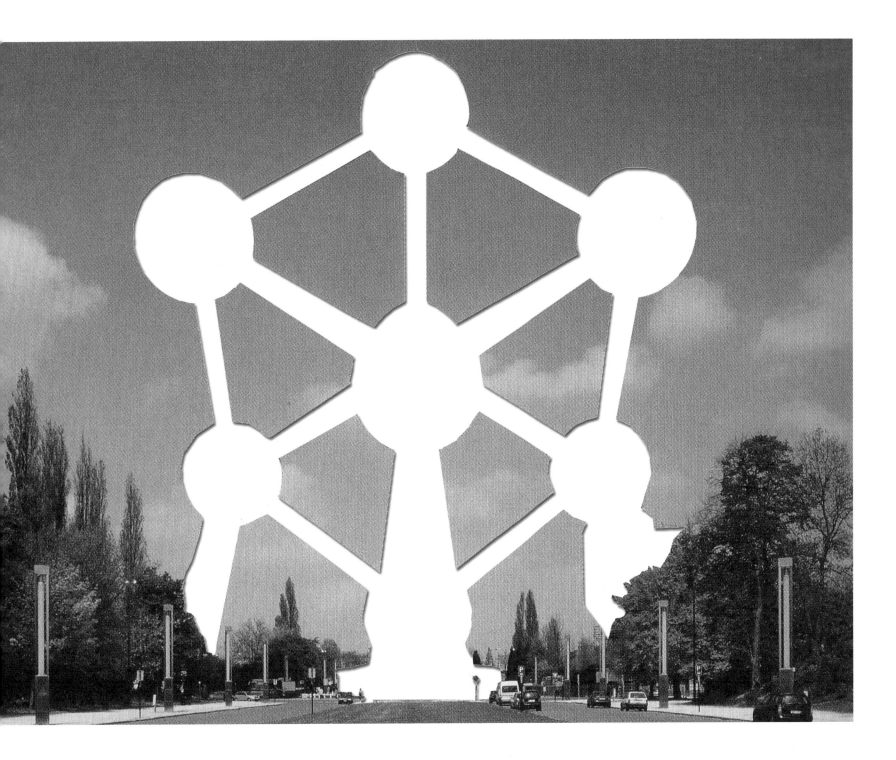

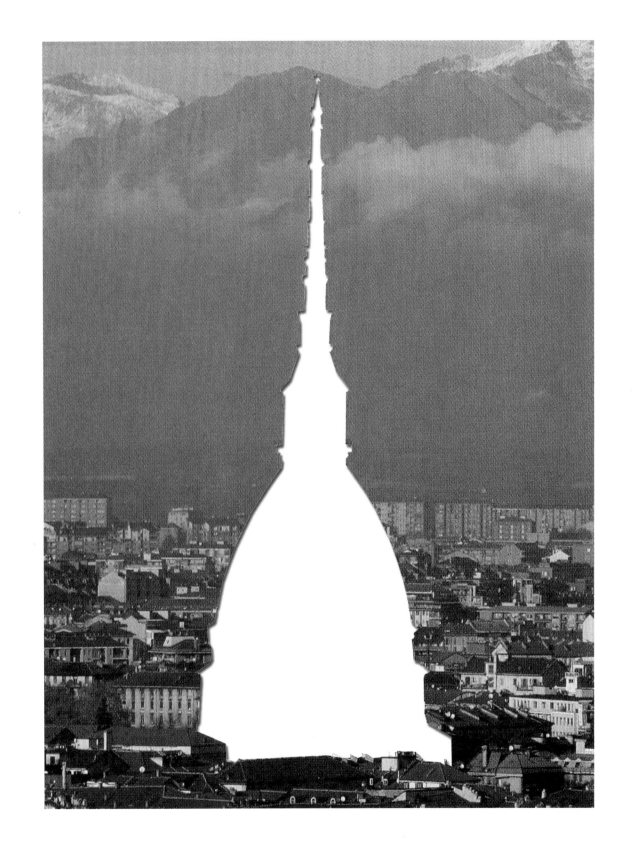

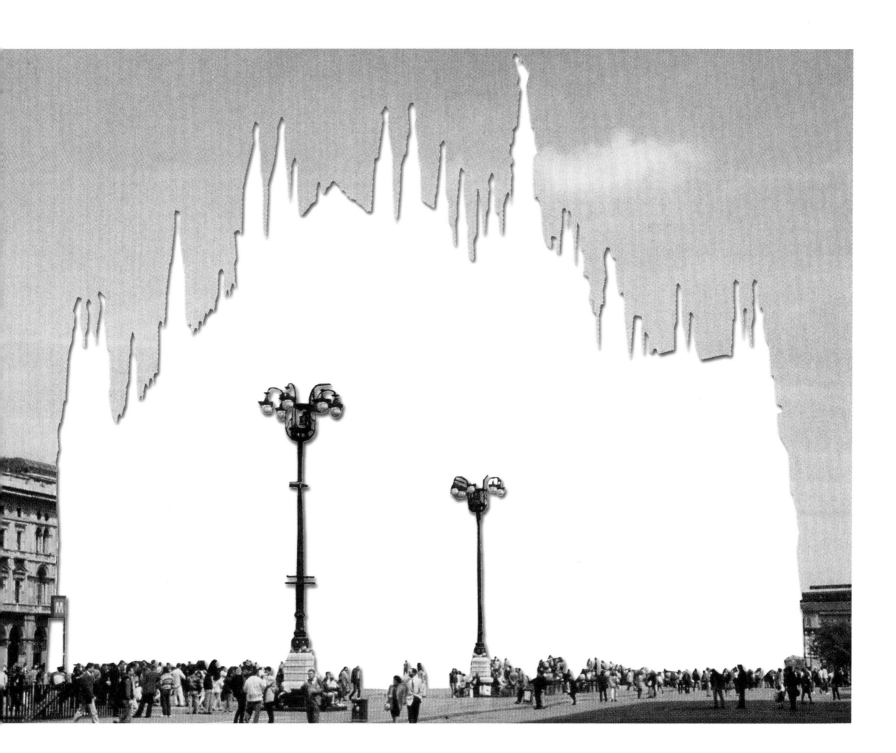

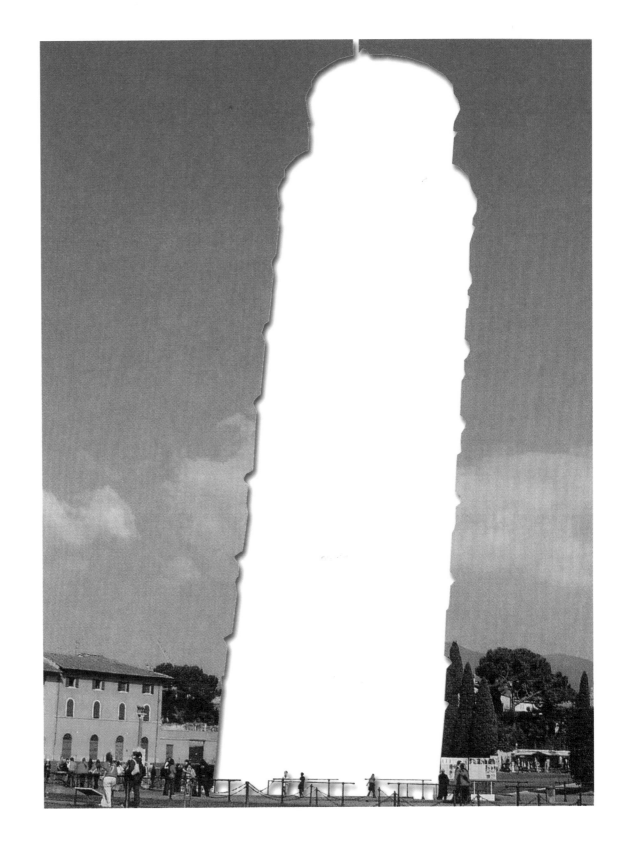

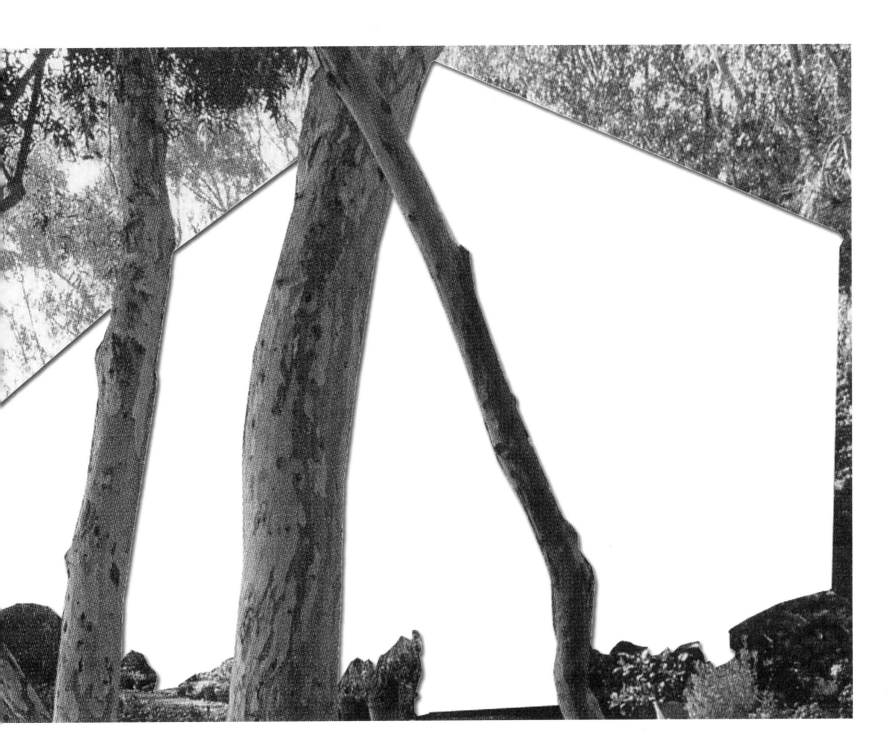

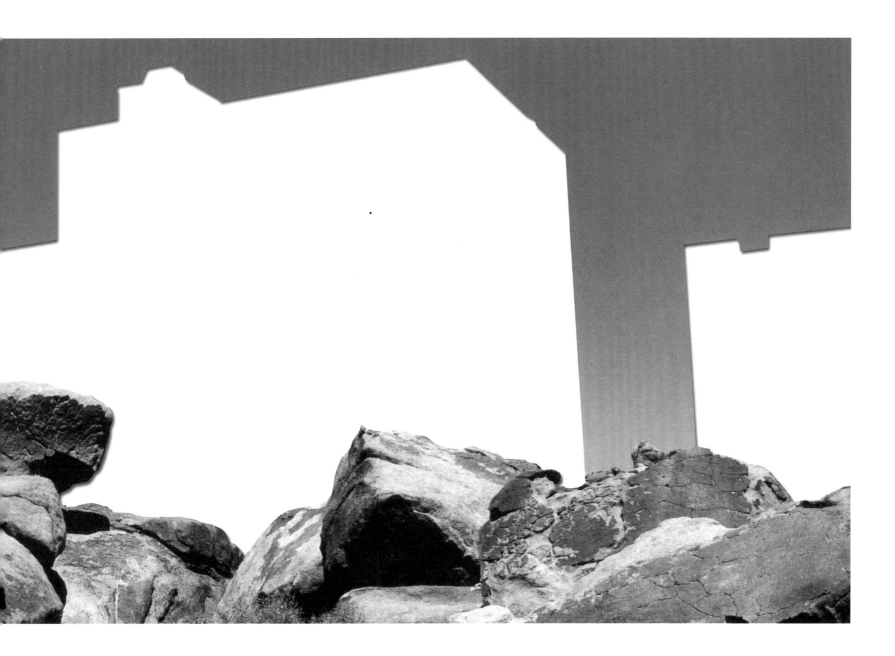

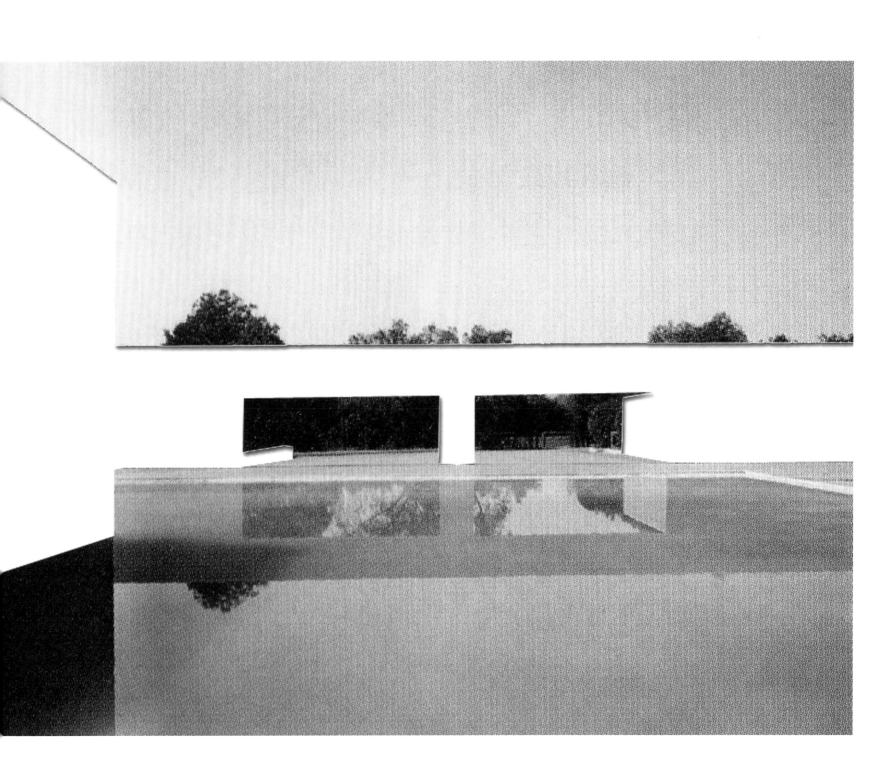

2560 BCE
GREAT PYRAMID OF GIZA,
EL GIZA, EGYPT
138

C 2100 BCE
ZIGGURAT OF UR,
NEAR NASIRIYAH, IRAQ
146

C 7TH CENTURY
VIRUPAKSHA TEMPLE,
HAMPI, KARNATAKA, INDIA
156

686
ISE GRAND SHRINE,
ISE, MIE PREFECTURE, JAPAN
174

704
BIG WILD GOOSE PAGODA,
XI'AN, SHAANXI, CHINA
164

715
UMAYYAD MOSQUE,
DAMASCUS, SYRIA
140

C 889
ALHAMBRA,
GRANADA, ANDALUSIA, SPAIN
38

1105
ANANDA TEMPLE,
BAGAN, MYANMAR
162

C 1120
BASILICA OF ST. SERNIN,
TOULOUSE, FRANCE
66

1146
AUTUN CATHEDRAL,
AUTUN, BURGUNDY, FRANCE
80

1240
CASTEL DEL MONTE,
ANDRIA, PUGLIA, ITALY
128

1248-1880
COLOGNE CATHEDRAL,
COLOGNE, GERMANY
92

1260
CHARTRES CATHEDRAL,
CHARTRES, FRANCE
70

1299
PALAZZO VECCHIO,
FLORENCE, ITALY
110

C 1300
RAABJERG CHURCH,
ÅLBÆK, DENMARK
106

1345
NOTRE DAME DE PARIS,
PARIS, FRANCE
78

1364
WAWEL CATHEDRAL,
KRAKÓW, POLAND
130

1372
TOWER OF PISA,
PISA, ITALY
104

1386-1965
MILAN CATHEDRAL,
MILAN, ITALY
100

1397
TEMPLE OF THE GOLDEN
PAVILION, KYOTO, JAPAN
172

1495
TOMB OF ASKIA,
GAO, MALI, AFRICA
48

C 16TH CENTURY
TOWER HOUSES,
SANA'A, YEMEN
144

1506
SEVILLE CATHEDRAL,
SEVILLE, ANDALUSIA, SPAIN
34

1515
IMCHEONGGAK ESTATE BUILDINGS,
ANDONG, GYEONGSANGBUK-DO,
SOUTH KOREA
170

1547
CHÂTEAUX DE CHAMBORD, CHAMBORD,
LOIRE-ET-CHER, FRANCE
68

1561
ST. BASIL'S CATHEDRAL,
MOSCOW, RUSSIA
136

1566
LAHORE FORT,
LAHORE, PUNJAB, PAKISTAN
152

1575
SELIMIYE MOSQUE,
EDIRNE, TURKEY
134

1592
CHURCH OF THE MOST HOLY
REDEEMER, VENICE, ITALY
116

1597
TRIANGULAR LODGE, RUSHTON,
NORTHAMPTONSHIRE, ENGLAND
46

1604
HARMANDIR SAHIB,
AMRITSAR, PUNJAB, INDIA
154

1626
CRAIGIEVAR CASTLE, ALFORD,
ABERDEENSHIRE, SCOTLAND
40

1653
TAJ MAHAL,
AGRA, UTTAR PRADESH, INDIA
160

1687
SANTA MARIA DELLA SALUTE,
VENICE, ITALY
118

1727
PILGRIMAGE CHURCH OF ST. JOHN OF
NEPOMUK, ZELENÁ HORA, CZECH REPUBLIC
126

1729
MARBLE HILL HOUSE,
LONDON, ENGLAND
50

1736
MELK ABBEY,
MELK, AUSTRIA
124

1746
LAKE PALACE, LAKE PICHOLA,
UDAIPUR, RAJASTHAN, INDIA
150

1749
RADCLIFFE CAMERA,
OXFORD, ENGLAND
44

1769
SYON HOUSE,
LONDON, ENGLAND
52

1862
ADARE MANOR, ADARE, COUNTY
LIMERICK, IRELAND
32

C 1870
HOUSES OF PARLIAMENT,
LONDON, ENGLAND
56

1882-PRESENT
SAGRADA FAMILIA,
BARCELONA, SPAIN
74

1889
MOLE ANTONELLIANA,
TURIN, ITALY
98

1892
NEUSCHWANSTEIN CASTLE,
HOHENSCHWANGAU, GERMANY
108

1902
SANTA JUSTA LIFT,
LISBON, PORTUGAL
28

1912
KIRUNA CHURCH,
KIRUNA, SWEDEN
132

1921
EINSTEIN TOWER,
POTSDAM, GERMANY
120

1930
CHRYSLER BUILDING,
NEW YORK, NEW YORK, USA
20

1931
EMPIRE STATE BUILDING,
NEW YORK, NEW YORK, USA
14

1931
VILLA SAVOYE,
POISSY, FRANCE
76

1938
FIAT TAGLIERO BUILDING,
ASMARA, ERITREA
142

1939
FALLINGWATER,
MILL RUN, PENNSYLVANIA, USA
12

1942
CASA MALAPARTE,
CAPRI, ITALY
122

1948
CASA BARRAGAN,
MEXICO CITY, MEXICO
4

1949
EAMES HOUSE, PACIFIC
PALISADES, CALIFORNIA, USA
182

1951
FARNSWORTH HOUSE,
PLANO, ILLINOIS, USA
6

1952
UNITÉ D'HABITATION,
MARSEILLE, FRANCE
86

1955
NOTRE DAME DU HAUT,
RONCHAMP, FRANCE
90

1958
ATOMIUM,
BRUSSELS, BELGIUM
82

1958
SEAGRAM BUILDING,
NEW YORK, NEW YORK, USA
18

1964
MARINA CITY,
CHICAGO, ILLINOIS, USA
10

1966
WHITNEY MUSEUM OF AMERICAN
ART, NEW YORK, NEW YORK, USA
16

1968
CUADRA SAN CRISTOBAL,
MEXICO CITY, MEXICO
186

1973
SYDNEY OPERA HOUSE,
SYDNEY, AUSTRALIA
176

1973
WILLIS TOWER,
CHICAGO, ILLINOIS, USA
8

1977
FIRE ISLAND HOUSE,
FIRE ISLAND, NEW YORK, USA
22

1986
CHURCH OF HALLGRÍMUR,
REYKJAVIK, ICELAND
26

1986
LOTUS TEMPLE,
NEW DELHI, INDIA
158

1990
BANK OF CHINA TOWER,
HONG KONG
166

1990
MONUMENT HOUSE,
JOSHUA TREE NATIONAL PARK,
CALIFORNIA, USA
184

1992
MONTJUÏC COMMUNICATIONS
TOWER, BARCELONA,
CATALONIA, SPAIN
72

1992
RYUGYONG HOTEL,
PYONGYANG, NORTH KOREA
168

1993
VITRA FIRE STATION,
WEIL AM RHEIN, GERMANY
96

1996
NITEROI CONTEMPORARY ART
MUSEUM, RIO DE JANEIRO, BRAZIL
24

1997
BASEL SBB SWITCHTOWER,
BASEL, SWITZERLAND
94

1998
DOMINUS WINERY, YOUNTVILLE,
CALIFORNIA, USA
178

1998
SCHULHAUS PASPELS,
PASPELS, SWITZERLAND
102

1999
BURJ AL ARAB,
DUBAI, UNITED ARAB EMIRATES
148

1999
LORD'S MEDIA CENTRE,
LONDON, ENGLAND
54

2000
TATE MODERN,
LONDON, ENGLAND
58

2002
BERGISEL SKI JUMP,
INNSBRUCK, AUSTRIA
112

2002
DIRTY HOUSE,
LONDON, ENGLAND
62

2003
AMAZING WHALE JAW,
HOOFDDORP, THE NETHERLANDS
84

2003
USERA PUBLIC LIBRARY,
MADRID, SPAIN
36

2003
VISTA,
DUNGENESS, ENGLAND
64

2004
30 ST MARY AXE,
LONDON, ENGLAND
60

2004
SEATTLE CENTRAL LIBRARY,
SEATTLE, WASHINGTON, USA
180

2004
VACHERON CONSTANTIN WATCH
FACTORY, PLAN-LES-OUATES,
GENEVA, SWITZERLAND
88

2005
ALLIANZ ARENA,
MUNICH, GERMANY
114

2005
CASA DA MÚSICA,
PORTO, PORTUGAL
30

2008
THE PUBLIC, WEST BROMWICH,
WEST MIDLANDS, ENGLAND
42